The Art Forgers Colouring & Activity Book

by Pen De'Grof

Volume 1. Early 19th Century Rural Life

Copyright © 2023 Pen De'Grof
Greenjckdavey Publishing

All rights reserved.

ISBN: 9798396170919
Imprint: Independently published

Forgery disclaimer

The information contained in this book is for general informational purposes only and is not intended to be legal advice. I am not a lawyer and I am not qualified to give legal advice. Any thoughts expressed in this book are my own understanding and should not be construed as legal advice. If you need legal advice, you should consult with an appropriately qualified Law Expert.

The purpose of this book about art forgery is to provide readers with an informative look at the topic. It is not intended to endorse or encourage anyone to engage in any illegal activity related to art forgery. Rather, it aims to educate readers on the history and techniques of forgery, raise awareness and promote ethical practices within the art community. It is important to note that forgery is illegal and unethical, and should not be condoned or encouraged. Forgery involves the creation or alteration of a document, artwork, or other object to deceive others. This can have serious consequences for individuals and institutions who rely on the authenticity of such objects

In the case of art forgery, for example, buyers and collectors who pay large sums of money for what they believe to be original works of art are being defrauded. This can lead to significant financial losses, as well as damage to the reputations of artists, galleries, and other art institutions. Furthermore, forgery undermines the integrity of cultural heritage and historical records. When fake documents or artifacts are accepted as genuine, the historical record becomes distorted, and our understanding of the past is compromised.

As the author of this book, I do not condone or endorse the creation of forgeries and disclaim any liability for the misuse of the techniques and methods described in this book. The reader is solely responsible for ensuring that they use the techniques and methods described in this book for lawful and ethical purposes, and should consult with legal counsel if they have any questions regarding the legality or ethics of their intended use.

The author also recommends that the reader exercise caution and good judgment when using the techniques and methods described in this book, and should seek out extra appropriate training and guidance before attempting to create decorative fake paintings. The author assumes no responsibility for any damages or injuries that may result from the reader's use of the information and techniques contained in this book.

Safety
So, Please, Please remember, safety should always be your top priority when working with any materials or tools. It is always wise to read and follow the instructions carefully before beginning the project. Use protective gear such as gloves, eye protection, and masks if necessary. Be aware of the materials you're working with and their potential hazards, such as sharp objects, hot surfaces, or toxic chemicals. Make sure you work in a well ventilated area. Keep tools and materials away from children and pets. Use caution around open flames or heat sources. Dispose of any waste materials properly and avoid pouring chemicals down the drain or in the trash. If you experience any adverse reactions or injuries while working on the project, stop immediately and seek medical attention. Store finished projects and materials safely, away from heat or moisture. If you're unsure about any aspect of the project, seek guidance from a professional or experienced artist. By following these safety reminders, you can help ensure a safe and enjoyable art & crafting experience at home.

This book is dedicated to my Father
He made my Art possible.

Introduction.

This book on art forgery is intended to give the reader an informative insight into the subject. It is not intended to encourage or condone illegal activities related to the production or sale of counterfeit art. Rather, it is intended to educate readers about the history and techniques of forgery to raise awareness and promote ethical practices in the art world. It is written for educational purposes only. It is intended to provide the reader with an understanding of the techniques and methods of art forgery. This book may be useful to artists, art collectors, art historians, and anyone interested in the subject of art forgery or considering venturing into the production of legal decorative fakes.

There might be the temptation to use the contents of this book to make lots of money or turn art forgery into a weapon against an art market, dominated by avante-garde fashion, with dealers and reviewers frequently enriching themselves at the expense of gullible collectors and struggling artists. Perhaps some readers may harbour ideas to use art forgery as a challenge to these power structures and like some modern-day Robin Hood, raise money to support grass-roots organizations working for social and economic justice. Some people may believe that art and culture are used by the rich and powerful as instruments of oppression, and believe that by creating counterfeits or imitation artefacts, they are breaking through these systems of control and reclaiming cultural power for the people. So again, it is important that I point out to you that counterfeiting is illegal and unethical, and that the consequences of being caught can be severe.

Art forgery is the practice of creating fraudulent works of art to pass them off as authentic. If you are contemplating a life of crime, you might assume that their greatest risk is getting caught by the law, If so, I am afraid you are in for a nasty surprise. There are many other dangers that potential forgers must consider. Not least, these include facing the risk of revenge from wealthy clients, involvement with organized crime, and the possibility of being used by intelligence services for dangerous sting operations.

One of the biggest risks for forgers is the potential for revenge from wealthy clients who have been duped into purchasing fake works of art either by the artist or their middleman. Forgers often target high-end collectors and art dealers who are willing to pay top dollar for rare and valuable works of art. However, when these clients discover that they have been sold a fake, they may seek revenge against the forger. These wealthy citizens often have the status, money and power to act outside of the law. Their response can take many forms, ranging from lawsuits and public humiliation to more extreme measures, such as physical violence or even assassination. In some cases, the forger may not even know who their clients are, as they may be dealing with intermediaries or anonymous buyers. The fake may also be discovered a long time after it was originally sold, so any of the fake artefacts that are made could one day come back to haunt their maker.

Another risk for forgers is their involvement with organized crime. Some forgers work with criminal organizations to produce fake works of art, often as part of a larger money laundering scheme. This can put them at risk of retaliation from rival gangs, as well as exposure to law enforcement. Often, when an

independent forger is discovered in their territory, the artist is enslaved and put to work. The use of word enslaved is not just used here as a figure of speech. In addition, forgers may be discovered and approached by law and intelligence services to create fake artifacts for use in sting operations. Often these people will blackmail the artist into helping them with the threat of a long prison sentence. While this may seem like an exciting but very unprofitable adventure, it is not like the movies. It can be incredibly dangerous as the forger may again be putting themselves at risk of retaliation from the criminals they are helping to catch and will receive little to no help from their controllers. Once Forgers start on the path of of crime, they are forced to live secretly in the shadows for the rest of their life, often moving from town to town and even changing countries, to avoid putting themselves in harm's way. Ultimately, the risks associated with art forgery far outweigh any potential rewards, and artists would be wise to steer clear of this dangerous and illegal practice.

The good news is that there is a huge market for so-called "Legal Fakes" referred to as "Pastiches" or sometimes "Decorative Fakes". So first, for this book let us clarify the main areas of artworks. The words Fake, Forgery, copy and pastiche are often used interchangeably, especially in the media but they do have small but important differences. I must make clear that this is my understanding and I am not qualified to give legal advice and even for lawyers it can be a minefield to navigate.

Let us start with the easy one, copies. A copy of a painting is a direct replica of an existing artwork, made to reproduce it as faithfully as possible, usually for educational or decorative purposes. The goal is to create a replica that looks as close as possible to the original painting, including the colours, composition, and style. Copies can be made by hand, through techniques such as oil painting or drawing, or by mechanical means, such as printing or photography. This can also be accomplished with the help of a Camera Lucida, projectors and even apps on mobile phones.

A Pastiche, or Decorative Fake on the other hand, is a new artwork that imitates the style, techniques, or themes of a particular artist or period, without the intention of reproducing a specific existing work. Pastiche can be thought of as a homage or tribute to an artist or style, rather than a copy. In a pastiche, the artist may combine elements from various sources, to create a new work that references and builds upon the original style. The goal of a pastiche is not to create a replica but rather to create a new work that captures the spirit of the original style or artist.

Some artists take this one step further and believe they are "Channeling" the spirit of a dead artist who works through them. The Master artist and simulator Tom Keating reported having this experience. He once woke up to find he had created an entire painting during the night, apparently in his sleep, in the style of a famous grand master with no waking memory of painting it.

A fake, on the other hand, is a deliberate attempt to create an artwork that is intended to deceive others into believing that it is an authentic artwork by a particular artist. A fake artwork is created to trick people into thinking that it is an original work by the artist, even though it is not. Fakes can be made by adding forged signatures, dates, or inscriptions to a work, or by creating a new work in the style of a particular artist and then passing it off as a genuine work by that artist. Some like the notorious purveyor of art forgeries, John Drewe, went further and even forged fake provenances and art catalogues. These he

placed in public institutions and libraries in support of the artwork he had commissioned from the artist John Myatt.

Finally, a forgery is also a deliberate attempt to deceive others into believing that an artwork is an original work by a particular artist. However, in the case of a forgery, the artwork is not only intended to deceive but it is also created to deceive. In other words, a forgery is an exact copy of an existing artwork, made to pass it off as a genuine article. The goal of a forgery is to deceive buyers, collectors, or institutions into believing that they are acquiring an original work by a particular artist, even though it is a fake.

In summary, a pastiche is a new artwork that imitates the style or themes of a particular artist or period, while a fake is an artwork that is created to deceive others into thinking that it is an original work by a particular artist. A forgery, on the other hand, is an exact copy of an existing artwork, made to pass it off as a genuine article. This does not take into account the added problem of having the right to copy something which could be protected by copyright or trademarks.

In theory an artist is not necessarily obligated to describe their work as a pastiche, but it is generally considered good practice to do so if the artwork is intentionally made in the style of or as a homage to a particular artist or period. Providing such information can help the viewer better understand and appreciate the artwork. However, the omission of details about the artwork does not necessarily prove an intention to deceive. It is possible that the artist may have simply overlooked or forgotten to provide such information, or may not have realized that the artwork resembles the work of another artist or period. Although in some cases if the artist receives more money than would normally be expected for a similar item, that in itself is proof of deception. In old English Law, when Art Forgers were arrested they were often charged with gaining a pecuniary advantage by deception, to which the Artist would reply, "It's a fair cop Guv. Oh Lawd, what will my poor Mother say."

That being said, if an artist deliberately withholds information about the nature of their artwork, or makes false claims about its origin or authorship to deceive buyers, collectors, or institutions, this would be considered fraudulent and unethical behaviour. In such cases, the artist may be held legally responsible for their actions, and the artwork could be deemed a forgery or a fake, depending on the circumstances. Artists need to be transparent and honest about their work, to maintain the integrity of the art world and the trust of the art-buying public.

If a pastiche was sold on an online auction with just a basic description of the subject and the painting's size, and the buyer misidentified the painting and paid a greater sum than it is worth, the situation could lead to a dispute between the buyer and the seller. In general, it is the responsibility of the buyer to do their due diligence and research before making a purchase. If the seller did not provide any false or misleading information about the painting, and the buyer misidentified it and overpaid, the seller may not be held liable for any damages or losses incurred by the buyer. That said, one of the guiding principles of a trial would be if the defendant received more value than could be reasonably expected.

However, if the seller knowingly provided false or misleading information about the painting, or intentionally concealed information about its true nature or value, this could be considered fraudulent behaviour. In such cases, the buyer may have grounds to file a complaint with the auction and potentially pursue legal action against the seller to recover damages. Overall, both buyers and sellers need to be transparent and honest in their transactions and take steps to ensure that they are accurately representing the artwork being sold. This can help avoid misunderstandings and disputes, and maintain the integrity of the art market. Having stated this, Upmarket Auction houses typically classify the authorship of a painting they sell into one of several categories, often described as shades of the truth, which may include:

"By [Artist Name]": This classification is used when an artwork is believed to have been created entirely by the named artist, with no significant contributions from others.

"Attributed to [Artist Name]": This classification is used when an artwork is believed to be the work of the named artist, but there is not enough conclusive evidence to fully confirm authorship. This may be due to a lack of documentation, or because the painting's style or quality is not consistent with the artist's known body of work.

"Studio of [Artist Name]": This classification is used when an artwork is believed to have been created in the artist's studio, under their supervision, but with significant contributions from their assistants or apprentices.

"Circle of [Artist Name]": This classification is used when an artwork is believed to have been created by an artist or group of artists who were influenced by the named artist's style, but who are not definitively identified as the named artist or their studio.

"School of [Artist Name]": This classification is used when an artwork is believed to have been created by an artist or group of artists associated with a particular artistic tradition or school, but who are not definitively identified as the named artist, their studio, or their circle.

"After [Artist Name]": This classification is used when an artwork is a later copy or reproduction of a work by the named artist. This may be done for educational or artistic purposes but is not considered an original work by the named artist.

This gives an auction what is called in the Art Trade, plenty of "Wriggle Room" if a Buyer later complains which of course is a technical term. These waters are further muddied by the fact the great art masters often signed the works of their apprentices and students with their names. As a mark of approval, sometimes simply to increase the monetary worth of the painting. This is why paintings are often reclassified in the Art Market as each new generation of art assessors and critics downgrade some paintings and rediscover old ones and fortunes are won and lost.

These classifications may be based on a variety of factors, including the painting's style, composition, materials, provenance, historical context and most importantly profit. Auction houses may also consult with experts and specialists in the relevant field to help determine the most appropriate classification for a

particular artwork. If a modern unsigned pastiche using contemporary materials was presented for auction, it would likely be classified based on the style and quality of the painting, as well as any additional information known about its provenance or history and how convincing it was.

If the painting closely resembles the style of a known artist, it may be classified as "in the style of" or "after" the named artist. This would indicate that the painting was created as a homage or pastiche, rather than as an original work by the named artist. Alternatively, if the painting does not closely resemble the style of any known artist, it may be classified as "contemporary" or "anonymous", indicating that the authorship of the painting are unknown. This would make it worthless or a great painting waiting to be bought cheaply and discovered by an art dealer who could use his knowledge and expertise, however sketchy, to attribute it to a named artist and make a vast potential profit at the expense of the seller.

In any case, the auction house would typically provide a detailed description of the painting's style, materials, and any other relevant information in the auction catalogue or listing, to give potential buyers as much information as possible about the artwork. This information can help buyers make informed decisions about whether to bid on the painting and what price they are willing to pay for it. If selling privately on an online auction, the would-be creator of a Pastiche would be well advised to add a disclaimer of some sort to his sales description along the lines of the following:

> Disclaimer
> While every effort has been made to accurately describe the painting, the buyer is responsible for exercising due diligence before making a purchase. By bidding on this item, the buyer acknowledges and agrees that the seller is not responsible for any misidentification, misrepresentation, or other errors related to the artwork's authorship or value, and that the buyer assumes all risks associated with the purchase of this item. Bidding on this item is acceptance of these terms.

There is another danger facing the would be maker of decorative fakes. What happens if someone buys you lovingly made Pastiche and it turns up later as fake. If an artist is concerned about someone else turning a pastiche they have painted into a fake, there are a few steps they can take to help protect themselves. You must clearly, mark the artwork as a pastiche, making it clear that the artwork is not an original work by the named artist. This can be done through a clear and accurate description of the artwork, and by including any information about the materials, techniques, and stylistic influences that were used in creating the artwork. Perhaps by marking the artwork in some way that does not detract from it but yet is irremovable, like a brand mark? The Art Faker, Tom Keating was prone to write the message "This is a Fake" with some added spicy words, in lead white pigment on his canvases, before he started painting, to assist any Art Assessors that might X-Ray his work at a later date.

In any case you should keep detailed records of your artworks, including photographs, descriptions, and any other relevant information. This can help to establish the provenance and authenticity of the artwork and can be used as evidence if there is ever a dispute over the authorship of the artwork. Especially make sure that you have proof that a painting bears your name of authorship or is blank when sold.

You can use watermarks or other identifying marks. Try to work with reputable people. I know they can be hard to find, but ask around and use recommendations. You should consider working with ethical dealers and galleries that have a strong track record of selling authentic artworks. This can help to establish the authenticity and value of the artwork and can provide an additional layer of protection against fraud or misrepresentation. If you are concerned about the possibility of your pastiche being turned into a fake, you may want to consult with legal professionals who specialize in art law. These professionals can guide how to protect their artworks and their rights as artists and can help to prevent and address any instances of fraud or misrepresentation. They can also advise you on copyright, patents and trademarks.

Once a buyer has purchased an artwork, they generally have the right to do with it as they wish, including altering it. However, if a buyer were to alter an artwork in a way that significantly changed its appearance or meaning, this could be seen as a violation of the artist's moral rights. Moral rights refer to the artist's right to protect the integrity of their artwork and their reputation as an artist. In some countries, such as France, moral rights are protected by law and cannot be waived or transferred to another person. In most cases, the original artist is generally not liable if a buyer misrepresents an artwork they have purchased to sell it for more money unless there is proof of collusion. For instance, the Artist receives extra payment from the buyer. Once the artwork has been sold to a buyer, the artist's responsibility for the artwork typically ends, unless there is a specific agreement or contract between the artist and the buyer that stipulates otherwise.

The Land of Opportunity

As an artist with a background in creating decorative fake artefacts, you may find yourself with a wide range of career opportunities and industries to explore. That is besides the usual route of selling "legal fakes" of famous paintings or artefacts or creating copies for wealthy clients who want versions of their beloved artwork in all their homes. Or need copies to display for insurance purposes, while the real one is nestled away in their vault. While your skills may have been honed in the creation of fake objects, they are often just as valuable in the creation of authentic objects and the design and construction of objects for various industries.

One industry that often employs artists with this skill set is the movie industry. Film and TV productions require all manner of props, from weapons and vehicles to furniture and artwork. Artists with experience in creating decorative fake artefacts can put their skills to use in designing and creating these props, helping to bring the story to life on the screen. Similarly, the stage and theatre industries also require a wide range of props and set pieces, and artists with experience in creating decorative fake artefacts can be valuable members of these teams. They may work on everything from creating period-accurate furniture and decor to constructing large-scale backdrops and sets. There are also independent Prop Libraries that supply or rent props to the Entertainment Industry that always employ experienced artists.

Interior design is another industry that can benefit from the skills of artists with a background in creating decorative fake artefacts. You may be tasked with creating unique and eye-catching decorative elements for high-end residential and commercial spaces or designing furniture and fixtures that blend seamlessly with the surrounding decor. This is closely linked to the Antique trade where restoration is another area where artists with this skill set may find employment. As long as you do not accept a commission to restore a damaged old blank canvas to a finished painting in the style of a famous artist! An ability to create accurate reproductions of historic objects can be valuable in the restoration of antique furniture and other artefacts, helping to preserve these pieces for future generations. Museums and exhibitions are also potential employers for artists with experience in creating decorative fake artefacts. These institutions often require replicas of artefacts or period-specific pieces to help bring exhibitions to life, and artists with experience in creating these types of objects can be valuable assets to the team.

Finally, teaching is always a potential career path for artists with a background in creating decorative fake artefacts. You may be able to teach courses on a variety of topics from painting to prop-making or set design, passing your skills and knowledge on to the next generation. Artists may find opportunities in industries as diverse as fashion, advertising, and event planning. Your ability to create unique and eye-catching objects can be valuable in creating everything from runway shows and product launches to elaborate event decor. By staying open to new opportunities and exploring different avenues of your creativity, you can continue to grow and develop your skills while making a meaningful impact in your chosen industries.

Creating a Pastiche or Decorative Fake.

Creating a pastiche or even a forgery can be very time-consuming and challenging. However, with the right skills and techniques, it is possible to create something very difficult to distinguish from an original work of art. It is important to note that with how many precautions the forger takes, there is still a very good chance that their fake will be detected eventually. This is because several experts specialize in detecting forgeries. These experts have a trained eye for spotting inconsistencies in paintings and other works of art. Additionally, some scientific tests can be used to verify the authenticity of a work of art. These tests can identify the materials that were used to create the work of art, as well as the age of the work of art.

One of the most popular fields for fakes is early 19th-century watercolours and drawings. These are the art forger's bread and butter. Out of all the different mediums you can choose, it is watercolours and drawings that are the most relatively easy to fake and where many start their careers. Forgers choose them because, watercolours are a transparent medium, which makes it difficult to see the brushstrokes and other details that can help to identify a forgery. Drawings are also relatively easy to fake, as they can be created with a variety of materials, including pencil, charcoal, and pen and ink. For the most part, watercolours and drawings are also mostly undervalued and often seen as less valuable than paintings, so they are often not as well-documented as paintings, which makes it more difficult to identify forgeries. Which makes them a more attractive target for forgers.

Also, there is a big market for watercolours and drawings, with high demand among collectors and museums. This is because they are often more affordable than paintings, and they can be displayed in a variety of settings. There is also something about them that is more personal and intimate than paintings, which adds to their appeal. As a result of these factors, forgers can easily create forgeries of watercolours and drawings, and they can sell them for a profit.

Experts will often use their knowledge of the artist to identify any inconsistencies in the artwork. That is why forgers learn as much as they can about the artist and their work. In detecting art forgeries, the experts will examine a suspected forgery for signs of wear and tear, such as fading, cracking, or staining. Forgeries are often created using new materials, which will not show these signs. That is why forgers go to great lengths to get original materials contemporary with the artwork they are imitating.

SOURCING MATERIALS

When an art faker creates a pastiche watercolour, or in particular a "tiler" as it is called in the art trade, (which is named after forgers that copy individual pieces of a famous artist's work and then combine them on a canvas, like a jig saw or someone tiling a wall), the first step is to source the right materials. This includes finding the right type of paper, paint, and brushes. The paper should be the same type and weight as the paper that the artist was known to use or at least would have been available in that period.

THE PAPER

There are a few methods that an art expert or art appraiser will use to approximate the age of the paper that a watercolour painting is on. The first of these is by the watermark. Many papers have a watermark, which can be used to determine the paper's maker and date range. If you hold the paper up to a light source and look, you may find a subtle design or text that is visible when the paper is held at a certain angle. These watermarks can be researched to determine their date range. Seeing this watermark will often put the expert at ease but these watermarks, as you shall learn later, can be faked.

The colour of the paper can also be an indicator of its age. For example, many papers from the 19th century and earlier were off-white or slightly yellowed due to ageing and exposure to light. Paper can also give a clue to its age by its texture. Early papers were often handmade and may have a more irregular texture than machine-made papers from later periods. Art paper in the early 19th century was typically made from linen or cotton rags, which were beaten and processed into a pulp to create high-quality paper. This paper was generally thicker and more durable than the paper used for everyday writing, and it had a smooth surface that was ideal for watercolour painting and drawing. Some artists also used paper made from other materials, such as mulberry bark, but these were less common and more expensive. The quality of the paper was an important factor for artists, as it could greatly affect the final appearance and longevity of their artwork.

By far the most important consideration when dating paper is its provenance or the history of ownership of the painting or drawing. This can also provide clues about the age of the paper. For example, if the painting has been in the possession of a particular family for generations, it is likely to be at least as old as the earliest known ancestor who owned it. This coincides with the search for collector's stamp marks found on the back of old watercolours and drawings. Some collectors or galleries may have stamped their mark on the back of an artwork as a form of identification or branding. These are often accompanied by inscriptions or labels that identify previous owners or collectors of the artwork. These marks can provide valuable information about the provenance and history of the piece.

History Lesson

In the early 19th century, art paper often had a variety of patterns or textures on its surface. Here are some common patterns that were popular during that time:

Laid Paper: This paper has a subtle pattern of evenly spaced horizontal and vertical lines. The lines were made during the paper-making process when the pulp was pressed between metal wires or screens.

Wove Paper: This paper has a more uniform texture with no visible pattern. It was made using a different method than laid paper and was often considered to be of higher quality.

Chain Lines: These are the faint, evenly spaced lines that run parallel to the laid lines on laid paper. They were caused by the wires used in the paper-making process.

Watermark: This is a design or pattern that is impressed into the paper during manufacturing, often by using a metal stamp. It is visible when the paper is held up to the light and can help identify the paper's maker or date.

Marbled Paper: This paper has a swirling pattern of colours that resembles marble. It was created by dropping ink or paint onto the water and then carefully transferring the pattern to paper.

Sprinkled Paper: This paper has small dots or speckles added to the surface for decorative effect.

These patterns were often used in combination with one another, and variations existed depending on the paper maker and region.

Some common types of collectors marks found on the back of old watercolours and drawings also include small labels or inscriptions which may provide the name of the artist, the title of the work, and the date it was created. Sometimes the name of the previous owner or collector is included, along with relevant exhibition or auction information. Personal annotations by the collectors themselves are often found, such as an appraisal value or a record of when the artwork was purchased or sold.

Collectors or galleries may have placed a wax or paper seal on the back of the artwork as a form of authentication or to prevent forgery, along with numbers where institutions such as museums or universities may have assigned inventory numbers to artworks in their collections.

So, aware of all these hurdles where does the faker and forger begin? The first step is obtaining paper of the right age without raising suspicion. Luckily, for the faker, there is a ready supply of authentically dated paper available. These are called "Breakers" in the trade and refer to old damaged books that have little

value because the covers have become detached, pages are missing or the engravings and pictures have been removed to be hand-tinted because sold individually they are worth more than the complete books. Every book dealer, bookshop, thrift shop and charity shop ends up with a box full lying around. What the faker seeks are detached clean blank front pages and endpapers. The clean extra pages at the front and end of each book. The publishing date, often on the title page, supplies the year of the paper.

The faker making legal works can simply ask for these sheets, a forger has the added problem of protecting his anonymity, and cannot approach his local second-hand book dealer asking for blank paper because that would simply give the game away. A common ploy is to pretend to the book dealer that the forger is a would-be bookbinder who is looking for broken books to practice on. Bookbinding and restoration are other skills you could get under your belt, they will teach you a lot about paper and its care and renovation.

Book dealers will often also sell watercolours and tinted prints and are good people to cultivate for their contacts with other book dealers and the antique trade. A knowledge of bookbinding would allow you to rebind old books and replace the blank front and back papers with modern papers. (Please do not just destroy old books, remember we are creators, not destroyers). Eric Hebborn used to haunt antiquarian bookshops that offered prints for sale. He was especially interested in old prints on thick paper. These he would buy and carefully split apart, giving himself a sheet of old paper and a genuine print to resell.

He achieved this delicate task by glueing linen (old tea towels) to both sides of the print with a strong flour paste, even ironing it, to make sure it was stuck firmly. When it was dry he would very gingerly and carefully pull the two pieces of linen apart, leaving a piece of paper stuck to each cloth. One the print, the other blank. These two sheets he would soak off and dry. He also kept his eye out for old ledgers and account books with blank pages that could be dated to the first entry in the book.

To remove any dirt that is not ingrained into the paper you find, first stretch it on a board with gummed tape, to stop it warping. Then you can cover the dirty places with flour paste and afterwards wash it away. If this does not work entirely, you can also try laying the paper in a fingernail's depth of water, in a tray still attached to the support, that you can put on a window sill with full sun for a few days. Then remove and leave to dry. The support should stop the paper from warping or crinkling as it dries. Finally, if none of this works, cry curses to the sky, go and have a nice warm cup of tea or coffee. Then come back, and if you think the paper is strong enough, you can dissolve salt in some hot pure lemon juice. Spread it on the paper and leave it for an hour, then wash it off with boiling water. This time, the sheets must be allowed to dry naturally with no artificial heat or sunlight.

Activity

Another solution to obtaining your paper is to make your own handmade paper. For this, you can use pieces of paper gathered from the book method that are too small to use, scraps from cutting, or even plain coloured old cloth.

To make home-made paper for artwork, you will need:

Old paper, Water, A blender, A Fabric screen. This can be made from a variety of materials, including cotton, linen, and hemp. Fabric screens are relatively inexpensive and can be reused many times. A frame and a thick cardboard or thin wood insert. A weight, A bowl. A spoon

Proceed by tearing the old paper into small pieces. You must soak the paper pieces in water for at least 30 minutes but preferably longer until they are soft and mushy. You now blend the paper pieces in a blender until they form a pulp. Pour the pulp into a bowl and stir in any additives you may think it needs, (See below). You need to fix the cloth mesh to the frame and then pour a thin layer of pulp onto the surface of the mesh screen. This can be a bit messy, so doing it over a big draining board will help. Try to spread the pulp evenly. You now have to place the cardboard or wood insert on top of the pulp with a weight added on top. Let it dry for at least 24 hrs. Once it is dry, carefully peel it off the mesh. Cut it to size and iron it if you want a smooth surface. Remember to keep any scraps to add to your next batch. To iron homemade paper, set your iron to a low heat setting and place a piece of parchment paper or a clean tea towel over the paper. Iron the paper for a few seconds at a time, moving the iron back and forth in a smooth motion. Be careful not to overheat the paper, as this can cause it to scorch or burn.

You can use size or flour paste to make your homemade paper stronger and more durable. Size is a type of glue that is made from gelatin. The ratio is to dissolve 25g (1oz) of gelatin for every litre (2 pints). You could also use Starch instead. Flour paste is a type of glue that is made from flour and water. To add size or flour paste to your homemade paper, simply stir it well into the pulp before you pour it onto the mesh screen. The amount of size or flour paste you add will depend on how strong you want your paper to be. Natural dyes, food dyes or watercolour paint can also be added to the pulp to tint its colour. Coffee, tea and chicory may all be used for the tinting of papers. With a little practice, you can make paper that is just as good as, if not better than, store-bought paper.
TIP: A watermark can also be added by placing a design made of copper wire on the mesh before pouring it into the pulp.

MENDING TEARS (In the paper not the eyes.)

If you have found the perfect piece of old paper to use but it has a tear, do not worry this can be easily fixed and give you a psychological advantage over the experts as well. You simply hold the torn edges together or fix them temporarily on the front side with low tack masking tape, or tape you have stuck to your shirt sleeve a few times and pulled off, to reduce its stickiness. Then on the reverse of the paper, paste on a piece of Japanese rice paper to support the tear. When it is all dry, remove the masking tape. Not only has this technique stood the test of time, used by book renovators and museums but the sight of the repair will instill confidence in an examining expert or prospective buyer that the drawing or watercolours is something worth repairing.

ADDING A WATERMARK

A way to add a watermark to your paper is to simply paint it on the back of the paper in light cooking oil, like poppy oil, with a thin brush. Experiment first on scraps of the paper to see which oil is the most suitable. The watermark should appear when the paper is held up to the light. If the oil stain appears too prominent on the back of the paper, it can be disguised by a sprinkle of powdered chalk or talcum powder. Then cover the watermark with a piece of paper and pass a hot iron over it. Another tip with grease spots is to rub half of a potato over the mark and this will normally permit you to draw over the area with ink, which would not otherwise take.

REMOVING FOXING

Sometimes you may find brown spotting on your discovered paper hoard. This is called foxing and refers to the brownish stains that can develop on paper over time due to various factors such as humidity, ageing, and exposure to pollutants. There are some methods you can try for removing foxing from old paper. You can dry clean the paper using a soft brush or a chemical sponge. This method is best for papers that are not heavily foxed.

Bleaching involves using a weak solution to remove the foxing. However, it should be used with caution as it can weaken the paper fibres and cause additional damage if not done properly. You can try a dilute solution of hydrogen peroxide, but it is recommended to seek professional help if the paper is valuable.

You can try washing the paper with a solution of distilled water and calcium hydroxide to remove foxing. This method should only be used for papers that are not heavily foxed and should be done by a professional conservator.

The paper can also be put through a method of de-acidification. This involves using a solution of magnesium bicarbonate to neutralize acids in the paper that can cause foxing. It can be effective in preventing further foxing, but it will not remove existing foxing stains. Most of all it is important to store paper in a cool and dry environment to prevent foxing and other types of damage. TIP: To simulate foxing, you can wet the area and flick dry instant coffee powder at it or dregs from your coffee cup.

INKS

There are still firms making old inks to their original recipe but if you want you can make this authentic 19th-century-style drawing ink at home using this old artist's recipe, you will need the following ingredients:

1 cup of water

1/4 cup of Gum Arabic

1 tablespoon of iron sulfate (also known as copperas)

1 tablespoon of Gum Senegal

1/2 teaspoon of logwood crystals

A few drops of vinegar (optional)

Bring the water to a boil in a little pan. Then add the Gum Arabic and stir until it is completely dissolved. After turning off the heat, remove the pot and give the mixture some time to cool. First add the Iron Sulfate and Gum Senegal to the mixture, stirring well after each addition. This is followed by adding the logwood crystals to the mixture, stirring until they are completely dissolved. If you want you can add a few drops of vinegar to adjust the pH of the ink. Now, pour the ink into a clean, airtight container and let it cool to room temperature.

Your home-made 19th-century-style drawing ink is now ready to use! This ink can be used with a dip pen or brush on paper or other drawing surfaces. It is important to note that this ink contains Iron Sulfate, which can be corrosive to some pens or nibs. Therefore, it is recommended to use a separate pen or nib for this ink. Also, be sure to store the ink in a cool, dry place away from sunlight to prevent spoilage.

Logwood is a natural dye that comes from the heartwood of the logwood tree, which is native to Central America and the Caribbean. It produces a deep purple or reddish-brown colour and was commonly used in the 19th century as a dye for textiles, as well as a colouring agent for inks and paints. The Logwood crystals in the recipe can be replaced with synthetic dyes such as Alizarin Crimson or Phthalo Blue. These dyes can produce similar shades of purple or reddish-brown as logwood. They can be found at art supply stores or online retailers that specialize in pigments and dyes.

Acacia gum, commonly referred to as gum Senegal, is a pure gum derived from the sap of the Acacia Senegal tree. It has adhesive and binding properties and was used in the 19th century as a binder in ink formulations. It also helps to improve the flow of the ink and prevent it from drying out too quickly. The Gum Senegal can be replaced with other natural or synthetic binders such as more Gum Arabic, which has similar properties and is already present in the recipe. Other options that could be used by fakers but not forgers include synthetic binders such as methyl cellulose or polyvinyl alcohol, which are commonly used in modern ink formulations.

Both Logwood and Gum Senegal can be found in art supply stores or online retailers that specialize in natural dyes and pigments. It's important to note that when using alternative ingredients, the resulting ink may not be an exact match to the 19th-century ink recipe. Additionally, different ingredients may require adjustments to the proportions or preparation of the ink. It may be helpful to experiment with small batches of ink to find the recipe that works best for your needs.

WARNING: The ingredients in the recipe for 19th-century-style drawing ink can potentially be harmful to health if not handled properly. Here are some things to keep in mind. Logwood crystals can be a skin and eye irritant, and inhalation of the dust can cause respiratory irritation. It's important to handle logwood crystals with care and wear protective gloves and a mask when working with them. Potassium or sodium hydroxide can cause skin irritation and burns. It's important to handle these chemicals with care and wear protective gloves and eye protection when working with them. Ferrous sulfate can be toxic if ingested in large quantities. It's critical to keep dogs and children away from this substance.

A more natural ink recommended by Tom Keating is made by boiling up walnuts. Sometimes adding some rusty old nails that have been left out in the rain, which in turn can also be made more rusty by soaking them in vinegar. After simmering off the water, leave the mixture to cool off. When it is cold, strain it through cloth and decant for a brown bistro ink. In his memoir "The Fake's Progress", he tells us that he prepared his tints of sepia ink for the 'Samuel Palmers' he faked, in an ice cube tray, with the colouring in each compartment varying in brightness from light to dark.. The soot of beechwood mixed with a binder and water was also used in medieval times. Most of those inks that are referred to as Indian and Chinese inks are usually made from soot of some sort (beech, pine or willow), mixed with a medium like gum or even oil. It is best to avoid modern inks that glisten as they may contain varnish that will affect the watercolour paints if used with them. Sepia was originally made from the dye of the cuttlefish and did not come into general use until the late eighteenth century. Sepia in the form of good-quality watercolour is perfectly acceptable, providing the binding material is Gum Arabic.

PENS
In the early 19th century, artists and writers used a variety of pens and nibs to create their work. A Reed or Cane pen is best for very large writing, of great use in studying pen strokes and forms. A Quill is best for smaller writing and is used for all ordinary work and was the most common type of pen, made from the flight feathers of geese or swans. The tip of the quill was cut at an angle to form a nib, which was then sharpened to a point.

Another type of pen used during this time was the metal dip pen, which had a removable nib that could be replaced as it wore out. The nibs for these pens were made from a variety of materials, including steel, gold, and silver. The Gillott company, founded in 1827, was one of the most prominent makers of nibs during the early 19th century. They produced a wide variety of nibs, including the popular "mapping" nibs, which were used for drawing maps and architectural plans. Other popular pens during this period included the reed pen, made from a single reed, and the bamboo pen, made from a single piece of bamboo. These pens were typically used for drawing and calligraphy.

ACTIVITY

Yes, a quill pen can be made at home. Here's a simple method to make a quill pen:

Materials needed: A feather (preferably a primary flight feather from a goose or swan)

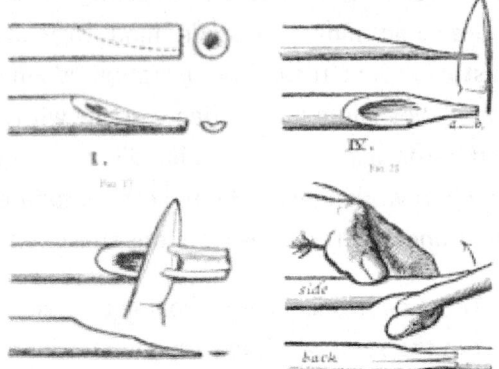

A sharp knife, A pair of scissors, Ink

Instructions:
Select a feather with a straight, sturdy shaft. The best feathers to use are the primary flight feathers from the wings of geese or swans. The feather should be cleaned and dried before use. First cut off the tip of the feather using a sharp knife. Make sure to cut it at an angle to create a pointed tip. Then cut a slit at the pointed end of the feather. The slit should be about 1-2cm long and about 1-2mm wide. You now need to trim the sides of the slit to create a smooth writing surface. Cut off the top of the feather, leaving about 2-3cm of the shaft to hold on to. Dip the quill pen in ink and test it on a scrap piece of paper. (A fuller description can be found in "Writing & Illuminating & Lettering", by Edward Johnston and there are free versions available online), Your quill pen is now ready to use!

BLOTTING PAPER

An early 19th-century artist would use blotting paper to absorb excess ink or watercolour. Blotting paper was made from unsized paper that was pressed in hot rollers to make it more absorbent. The paper was then cut into sheets and sold for use as blotting paper. The artist would place the blotting paper over the wet ink or watercolour and press it down gently with their hand or a blotter. This would absorb the excess liquid and prevent smudging or bleeding. Blotting paper was invented in England in the early 19th century, around 1803, by a man named Bryan Donkin. It was initially used as a way to remove excess ink from quill pens and later became popular as a way to absorb excess ink from fountain pens. TIP: A small piece can also be used as a barrier between the hand and the artwork to avoid smudging.

PENCILS

While there have been technological advancements in pencil manufacturing, the fundamental purpose and functionality of pencils have remained largely unchanged over the past two centuries, with the basic design having remained relatively unchanged. In the early 19th century, pencils typically used a "lead" core made of a mixture of lead and clay. Today, pencils still use a similar composition, although the term "lead" is misleading since graphite is used. However, modern manufacturing processes have allowed for a more consistent and precise mixing of graphite and clay, resulting in pencils with better quality and performance. Some tests are available for experts to use on the composition of graphite and clay used in drawings but they are not completely reliable and can damage the test piece. If a forger wants to be completely authentic there are often older pencils found in boxes of bits and bobs in thrift stores and antique markets. TIP: Short stubby ones can still be used in pencil extenders.

The modern classification and standardization of pencil grades have evolved since the 19th century. Today, pencils are typically labelled with a number and/or letter combination that indicates their hardness or softness (e.g., 2B, HB, 4H). This system allows users to select pencils with specific lead characteristics suitable for their needs.

TIP: When sourcing older pencils check to see they not have these identification letters & numbers.

BRUSHES

Early 19th-century artists used a variety of paint brushes, depending on their personal preferences and the specific techniques they were using. It's worth noting that brushes during this period were often made from natural materials such as animal hair, including sable, goat, and horse hair. The handles were typically made of wood or bone. However, some common types of brushes used during this time include:

Round brushes: These brushes have a pointed tip and are ideal for creating fine lines and details.

Flat brushes: These brushes have a straight edge and are useful for covering large areas with paint and creating broad, flat strokes.

Mop brushes: These brushes have a large, round shape and are used for applying washes and creating soft, blended edges.

Fan brushes: These brushes have a flat, fan-like shape and are used for creating texture and blending colours.

Rigger brushes: These brushes have a long, thin shape and are used for creating fine lines and details.

Liner brushes: These brushes have a long, thin shape similar to rigger brushes, but with a shorter bristle length. They are also used for creating fine lines and details.

Scrubber brushes: These brushes have stiff, coarse bristles and are used for scrubbing paint into the surface of the paper to create texture.

CHARCOAL AND FIXATIVES

Tom Keating recommends making your charcoal at home by filling a lidded tin can with willow twigs, sealing it and putting it in the garden bonfire. I did this in an old Tate & Lyle syrup tin which was ideal, except after 10 minutes it exploded like a small bomb, having neglected to make the few air holes. A nail and hammer as recommended. (TIP: Do not forget to save any dust in the tin to make ink). You can seal a charcoal drawing to prevent smudging by heating some milk in a pan until it boils. Then let it cool down a bit until it is warm to the touch. Take a clean sponge or cloth and dip it into the warm milk. Now you gently rub the milk onto the surface of your charcoal drawing, covering the entire area. Then allow the milk to dry completely. Once the milk has dried, gently wipe the surface of the drawing with a clean, dry cloth to remove any excess residue.

Egg white, on the other hand, is a protein-based material that can also be used to seal charcoal drawings. To use egg white, the artist would beat an egg white until it became frothy, and then use a brush to apply a thin layer of the egg white to the paper. Once the egg white had dried, it would form a hard, transparent film that would help to protect the drawing. It is worth noting that some of the other fixatives that were used in the past, such as shellac or lacquer, may have yellowed over time and damaged the paper.

When dry, Gum Arabic forms a water-soluble film that can be re-wetted if it comes into contact with water. This means that it is not entirely waterproof and can smudge or dissolve if exposed to moisture. However, Gum Arabic can still provide a protective layer for artwork, especially when used as a binder in watercolour paints. It also helps to adhere pigment to the paper and improve the flow of the paint.

It is possible to paint over a layer of dried Gum Arabic with additional watercolours, as long as the new layer is applied gently and with care to avoid disturbing the underlying layer. However, it is important to note that repeated applications of water can cause the Gum Arabic layer to break down and become less effective over time.

Early 19th-century artists typically used a combination of methods to seal their watercolour paintings and drawings before adding another layer as in the use of glazes. One common method was to apply a thin layer of Gum Arabic or gelatin size to the surface of the painting, which would help to bind the pigment to the paper and protect it from moisture. This layer would need to be completely dry before adding another layer. Another method was to use a fixative spray made from a mixture of Gum Sandarac (a resin) and alcohol, which would help to fix the pigment in place and prevent smudging.

The fixative would need to be applied in thin layers, allowing each layer to dry before adding another. Some artists also used varnishes, such as Damar varnish or mastic varnish, to seal their watercolour paintings. These varnishes would need to be applied in thin layers and allowed to dry completely before adding another layer of watercolour. It is important to note that some of the methods used to seal watercolour paintings in the early 19th century may not be suitable or recommended for use today, as some of the materials used may be toxic or harmful to the artwork over time.

PAINTS

Several tests could expose the forgery. One test that could be used to detect a forgery is called an X-ray fluorescence (XRF) test. This test can identify the elements that are present in a painting. If the forger uses modern pigments that were not available when the original painting was created, the XRF test will be able to detect this. Another test that could be used to detect a forgery is called a pigment analysis. This test can identify the specific pigments that are used in a painting. If the forger uses modern pigments that were not available when the original painting was created, the pigment analysis will be able to detect this.

There are a few ways that an art forger can check that his watercolours are available in the year that his forgery was supposed to be painted. One way is to research the history of watercolours and find out when they were first invented and when they became commercially available. Another way is to look at catalogues and price lists from art supply stores from the time in question. Finally, an art forger can also contact art historians and conservators who may be able to provide more information about the availability of watercolours in a particular period.

There is no single list of what watercolours became available for sale at what times. However, some resources can be used to research this information. One resource is the book "Watercolour: A History" by David Bomford. This book provides a comprehensive overview of the history of watercolours, including information about the development of different types of watercolour paints and brushes. Another resource is the website of the Royal Society of Chemistry. This website has a section on the history of chemistry that includes information about the development of watercolour paints.

WATER PAINTS

An art forger can also lessen the chances of their crime being discovered if they teach themselves to make their watercolours paints from pigments and distilled water. In the early 19th century, watercolours were made differently than they are today. The artist would begin by grinding the pigment (ground minerals or plant-based materials) into a fine powder using a mortar and pestle. This step was important to create a fine, even texture in the paint. The powdered pigment would then be mixed with a small amount of gum Arabic and water in a palette. Gum Arabic acted as a binder to hold the pigment together and adhere it to the paper. Sometimes a small amount of honey was added. The artist would then dilute the mixture with water to create different shades and hues of the pigment. This step required careful attention to create the desired colour and consistency.

Oil paint was made the same way but using oil as a binder instead of gum. At the time most artists were experimenting with what we now called mixed media. Turner experimented with water mixed pigments on his canvas instead of oil paints. Sealing each layer or glaze with varnishes or gums before proceeding. This enabled him to produce paintings quickly by decreasing the drying time compared to oils. Some artists used watercolours or aqueous paints as they called them, to complete the under painting. Then it was sealed and finished in oils. This method can be used today by painting the picture in acrylics and when it is dry finishing it oil paints and finally varnishing it.

One New York gallery proudly exhibited a Renoir in their front window until a passer-by pointed out the original was still in the Louvre in Paris. It was later found to be painted using this acrylic based method. Samuel Palmer went in the other direction and imitated oils by adding ever thicker amounts of Gum Arabic to his watercolours in an attempt to recreate the shine and thick brush strokes.

ACTIVITY
Making watercolours at home is a fun and creative activity.

Here's how you can make them:

Materials:
Baking soda, White vinegar, Cornstarch, Honey or Light corn syrup, Glycerin. Food colouring, Small containers (such as ice cube trays or pillboxes), Lolly Sticks Watercolour paper, Paintbrushes, Water.

Instructions:
In a mixing bowl, combine 4 teaspoons of baking soda and 2 teaspoons of white vinegar. Stir until the mixture stops fizzing. Add 4 teaspoons of cornstarch, 2 teaspoons of honey or light corn syrup, and 1 teaspoon of glycerin to the mixture. Stir until the ingredients are well combined. Add a few drops of food colouring or natural pigments to the mixture and stir until the colour is evenly distributed. Pour the mixture into the small containers, filling them about halfway full. You can recycle old yogurt ports or plastic food containers you were going to throw away. Use a lolly stick to add more food colouring to the mixture to adjust the hue and saturation to your liking. Let the mixture dry for several hours or overnight until it hardens. Once the mixture is completely dry, pop the watercolours out of the containers. To use the watercolours, wet a paintbrush with water and dip it into the watercolour paint. Apply the paint to the watercolour paper to create your artwork.

Tips:
Experiment with different colours and colour combinations by mixing different amounts and colours of food colouring. Adjust the consistency of the watercolours by adding more or less water when you use them. Store your home-made watercolours in an airtight container to keep them from drying out. If you prefer a smoother texture, you can grind the mixture with a mortar and pestle before pouring it into the containers.

GUM ARABIC

Gum Arabic is a versatile watercolour medium that can be used to achieve a variety of effects. It is a safe and non-toxic substance that is easy to use. If you are looking for a way to improve the quality of your watercolour paintings, adding gum Arabic is a great option. It is used to increase the opacity of

watercolour paint and makes it more opaque which can help finish detailed paintings. Giving the painting a smoother finish, it can make it look more polished. The inherent stickiness of the gum also helps the pigment adhere to the paper more effectively, which can help to prevent it from smudging or fading. Artists have also found that among its properties it can slightly extend the drying time of watercolour paint, which can be helpful for artists who want more time to blend or manipulate the paint.

It is well to remember that only a small amount is needed, too much Gum Arabic can make the paint too thick and difficult to work with. It is best to add the Gum Arabic to your water before you add the paint. This will help to distribute the Gum Arabic evenly throughout the paint. Gum Arabic can be used with any type of watercolour paint, but it is especially effective with opaque paints. As far as is known Gum Arabic does not have any bad effects on watercolour paint in the long term. It can help to preserve the paint and make it last longer because it can help to protect the paint from environmental factors such as light and humidity. Gum Arabic is a natural substance that is extracted from the sap of the acacia tree. It has been used as a watercolour medium for centuries and is known to be safe and non-toxic.

OX GALLBLADDER

Ox gall is a substance that is extracted from the bile of cows. It is used as a wetting agent that helps the paint flow more easily and blend more smoothly. Ox gall is safe and non-toxic, but it can be expensive

GLYCERIN

Glycerin is a sweet, colourless liquid that is made from vegetable oils. It is used to add body and shine to watercolour paint. Glycerin is safe and non-toxic, but it can make the paint more difficult to clean up.

MICA

Mica is a mineral that is used as a pigment to add sparkle and shimmer to watercolour paint. Mica is safe and non-toxic.

SALT

Salt can be added to watercolour paint to create a variety of effects. For example, adding salt to wet paint can create a textured effect. Salt can also be used to create a resist, which is a pattern that prevents the paint from flowing. Salt is safe and non-toxic.

In general, adding substances to watercolour paint does not damage the paint in the long term. However, it is important to note that some substances can make the paint more difficult to clean up.

Here is a list of some but not all of the watercolour paint colours that were available for artists to purchase from 1800 to the present:.

Prussian Blue (1704)	Ultramarine violet (1905)	Phthalo Turquoise (1960s)
Cobalt blue (1807)	Cobalt violet (1909)	Quinacridone magenta (1960s)
Crimson Lake (1826)	Titanium White (1910)	Cobalt teal (1970s)
Hooker's Green (1835)	Phthalo Green (1910)	Nickel azo yellow (1970s)
Rose Madder (1835)	Phthalo Blue (1910)	Anthraquinone blue (1980s)
Cadmium yellow (1840s)	Cadmium red (1920s)	Indanthrone yellow (1980s)
Cerulean blue (ca. 1859)	Indanthrone blue (1925)	Pyrrole red (1990s)
Raw Umber (1860)	Mars Black (1920s)	Transparent pyrrole orange (1990s)
Burnt Sienna (1860)	Cerulean blue chromium (1930s)	Quinacridone gold (2000s)
Viridian (1862)		Lunar Black (2000s)
Naples Yellow (1870)	Dioxazine purple (1930s)	
Payne's Grey (1870s)	Quinacridone red (1930s)	
Gamboge (1870s)	Cadmium orange (1940s)	
Sap green (1880s)	Cobalt turquoise (1940s)	
Chrome yellow (1809)	Transparent oxide red (1950s)	
Alizarin Crimson (1880s)	Ultramarine pink (1950s)	
Indian Red (1880s)		

It is also important to note that the availability of specific colours of watercolour paint may vary depending on the brand and region. Additionally, this list is not exhaustive and there may be other colours that were available during

OIL PASTELS

Oil pastels, as we know them today, were not widely used by the old masters as they were developed in the 20th century. However, some artists did use a similar medium called "oil crayons," which were developed in the mid-19th century. One of the most famous artists to use oil crayons was Edgar Degas. He used them extensively in his later years to create vibrant, textured drawings of dancers and other figures. Degas appreciated the versatility of oil crayons and their ability to create rich, bold marks on paper.

Another artist who used oil crayons was Henri de Toulouse-Lautrec. He used them in combination with other media, such as charcoal and watercolour, to create vivid, expressive portraits of people and scenes from Parisian nightlife. Oil crayons were popular with artists in the 19th century because they allowed for a more painterly approach to drawing. They could be used to create thick, impasto-like marks, and their oil-based binder allowed for easy blending and layering of colours. They were also versatile enough to be used on a variety of surfaces, including paper, canvas, and board.

While oil pastels are a more recent development, they continue to be popular with artists today for many of the same reasons. They offer the ability to create bold, expressive marks with a variety of textures and colours, and their waxy consistency allows for easy layering and blending. When preparing pastel shades, clay, whiting, gypsum or talcum powder are sometimes mixed with the coloured pigments in place of white.

Making oil pastels at home is a bit more difficult than making drawing chalks and requires a few specialized ingredients, but it is possible to create them with some effort. Here's how you can make oil pastels at home:

Materials: Beeswax, Linseed oil, Dry pigment (ground minerals or plant-based materials), Glass or metal containers, Double boiler or pot and heat-safe bowl, Spatula or wooden spoon, Paper towels, Moulds, (such as empty toilet paper rolls or candy moulds), Wax paper.

Instructions:
Melt the beeswax and linseed oil in a double boiler or pot and heat-safe bowl over low heat. Stir frequently with a spatula or wooden spoon until the mixture is completely melted. Gradually add the dry pigment to the melted wax mixture, stirring constantly until the colour is evenly distributed. The amount of pigment you add will depend on the intensity of the colour you want to achieve. Pour the mixture into suitably shaped moulds lined with wax paper. Tap the mould gently to remove any air bubbles. Let the mixture cool for several hours until it hardens completely. Once the pastels have hardened, remove them from the moulds and clean up any excess wax on the surface. The pastels should be kept in a cool, dry area.

Tips: Experiment with different pigments to create a range of colours. Use a double boiler or heat-safe bowl to melt the wax mixture to avoid direct heat that may cause the mixture to burn. When pouring the mixture into moulds, try to keep it as even as possible to ensure consistent pastels. Store the pastels in a cool, dry place to avoid melting or softening.

To use Oil Pastels on paper you will have to prepare it first by creating a slight texture or roughness to the paper. You can achieve this by covering the surface with flour paste as smoothly as you can. Then sprinkle on as evenly as possible some powdered pumice stone. Gently shake the paper around and the pumice stone will stick to the exposed areas. Then tip the remainder off.

Since nearly all pastel drawings use tinted paper you can tint with pigment during the sizing process, by mixing colour pigment with the surface paste

OIL CRAYONS

The main difference between oil pastels and oil crayons is the binder used to hold the pigment together. Oil pastels are made with a mixture of pigment, wax, and oil, whereas oil crayons are made with a mixture of pigment, wax, and a non-drying oil such as mineral oil or castor oil. This difference in binder affects the texture and handling properties of the two mediums.

Oil pastels are typically softer and creamier than oil crayons, and they can be easily blended and layered on the surface of paper or canvas. They are also more prone to smudging and melting, and they may require special fixatives to prevent them from smearing. Oil crayons, on the other hand, are firmer and harder than oil pastels, and they have a waxy, matte finish. They do not smudge or melt as easily as oil pastels, making them more suitable for detailed work and fine lines. They are also easier to control and manipulate on the surface of the paper or canvas.

Overall, the choice between oil pastels and oil crayons will depend on the specific needs and preferences of the artist. Both mediums offer unique properties and can be used to create beautiful, expressive works of art. Making oil crayons at home requires a few specialized ingredients, but it is possible to create them with some effort. Here's how you can make oil crayons at home:

Materials: Beeswax, Paraffin wax, Non-drying oil (such as mineral oil or castor oil), Dry pigment (ground minerals or plant-based materials), Glass or metal containers, Double boiler or pot and heat-safe bowl, Spatula or wooden spoon, Paper towels, Moulds such as empty toilet paper rolls or candy moulds), Wax paper

Instructions:
Melt the beeswax and paraffin wax in a double boiler or pot and heat-safe bowl over low heat. Stir frequently with a spatula or wooden spoon until the mixture is completely melted. Add the non-drying oil to the melted wax mixture, stirring constantly until the mixture is well combined. The amount of oil you add will depend on the desired consistency of the final product. Gradually add the dry pigment to the melted wax mixture, stirring constantly until the colour is evenly distributed. The amount of pigment you add will depend on the intensity of the colour you want to achieve. Pour the mixture into moulds such as candy moulds lined with wax paper. Tap the mould gently to remove any air bubbles. Let the mixture cool for several hours until it hardens completely. Once the crayons have hardened, remove them from the moulds and clean up any excess wax on the surface. Store the crayons in a cool, dry place.

Tips: Experiment with different pigments to create a range of colours. Use a double boiler or heat-safe bowl to melt the wax mixture to avoid direct heat that may cause the mixture to burn. When pouring the mixture into moulds, try to keep it as even as possible to ensure consistent crayons. Use caution when working with hot wax to avoid burns. Store the crayons in a cool, dry place to avoid melting or softening.

CHALKS

White, black and red chalks are virtually the only ones used by the Old Masters.

Materials: Small handmade cardboard tubes or other cylindrical moulds, Wax paper, Scissors, Tape.

Instructions:

Cut your cardboard tubes into the desired length for your chalk crayons. Then, cut pieces of wax paper to fit over one end of each cardboard tube, and tape them securely in place. In a mixing bowl, combine 1 cup of Plaster of Paris with 1/2 cup of water, and mix until smooth. Add a few drops of tempera paint, children's paint or food colouring to the mixture, and stir until the colour is evenly distributed. Pour the mixture into the moulds, filling them about 3/4 of the way full. Tap the cardboard tubes gently on a hard surface to remove any air bubbles and level the mixture.

Let the mixture dry completely, which can take several hours or overnight. Once the mixture is completely dry, carefully remove the cardboard tube from the chalk crayons. Use a sharp knife or scissors to cut the chalk crayons to the desired length. Let the chalk crayons dry completely for another day before using them.

Tips:

You can experiment with different colours and colour combinations by using different amounts of tempera paint or food colouring. If you don't have cardboard tubes, you can use other cylindrical moulds such as large plastic straws or silicone moulds. Make sure to protect your work surface with newspaper or a plastic sheet, as Plaster of Paris can be messy and hard to clean up.

DO NOT TIP WASTE DOWN THE SINK! PLEASE DISPOSE OF RESPONSIBLY.

COMPOSITION

Once the materials have been sourced, the forger can begin to create the composition. This can be done by copying elements from other paintings by the same artist, or by creating a new composition altogether. If the forger is copying elements from other paintings, they will need to carefully select the elements that they want to use. They will also need to make sure that the elements are arranged in a way that is consistent with the artist's style. In terms of where the forger starts, it depends on their approach. Some forgers may start with large elements of the composition and then fill in the smaller details, while others may start with the smaller details and then work their way up to the larger elements. There is no right or wrong way to do it, as long as the final result is a convincing pastiche.

A well-balanced composition does not feel top-heavy or bottom-heavy. You can achieve balance by using a variety of techniques, such as using the rule of thirds, using leading lines, and creating a sense of depth. You can see artists checking the balance of their artwork by constantly stepping back and viewing it as a

whole, sometimes squinting or half-closing their eyes. A useful tip is to occasionally turn the picture upside down and view it that way

The use of colour can affect the mood of the painting and the viewer. You must be aware that the colours you use can create a certain mood or atmosphere. For example, cool colours, such as blues and greens, can create a sense of calm, while warm colours, such as reds and oranges, can create a sense of excitement. The added use of contrast can add interest by using contrasting colours, shapes, or textures.

Here are some basic rules of composition when painting

Use the rule of thirds. This is the generally accepted rule that states that the most visually appealing compositions divide the canvas into thirds, both horizontally and vertically, and then place the main elements of the painting at the intersections of these lines. There are more complicated forms of dividing up the composition but most of them overlap and overlay with the rule of thirds.

The use leading lines. Leading lines are lines that lead the viewer's eye through the painting. They can be natural lines, such as the horizon or a river, or they can be man-made lines, such as a road or a building. Remember that most people's eyes tend to start in the bottom left and want to be led to the top right.

Create a sense of depth. Use perspective to create a sense of depth in your painting. This can be done by using smaller, lighter shapes in the background and larger, darker shapes in the foreground. Warm colours like reds and browns tend to stand out and are best used in the foreground, while cooler colours like blue tend to recede and are best used in the background at the horizon.

Using the illustrations in this book, you have all the basic elements you need to create one of the the most popular Early 19th Century themed pictures, that of the rural English Countryside. When you purchase this book you also get the rights to use these illustrations anyway you want. You can copy them by hand using a light box or trace them, scan and print them with your computer or use them with a projector, it is up to you. It is probably best to start with main pieces of your composition foreground, like the cottage and then use the illustrations to fill in the surrounding areas. If you print out the pieces, you can move them around until the composition feels balanced, Do not forget, you can also scale the illustrations up and down in size.

STARTING THE PASTICHE

Once the composition has been created, the forger will begin to paint. They will need to use the same techniques and brushstrokes as the artist. If you are using pieces from an artist's original work combined into a new composition, you will need examples handy to copy. If you have composed a piece in the style of an artist but you have created a new composition, you will still need some reference pictures. It is important to establish the direction in which the light falls and where shadows will be cast. It is best to do some preparatory sketches, that you can can later choose, alter and transfer to your main work. You will also need to be careful to use the same colours and values. You can use straight lines to check your perspectives.

Luckily, there were widely read watercolour painting tutorials available in the early 19th century, written by some notable painters like David Cox and Samuel Prout to name but two. These books were studied by artists that came after them, including recognisable names like Constable, Turner and Palmer. So, these manuals by our fellow artists are where forgers often turn for help. David Cox was a 19th-century English landscape painter who is best known for his watercolours. He was a prolific artist, and is said to have produced over 10,000 works of art during his lifetime. As a great admirer of nature, he often painted landscapes from his observations. He was particularly interested in painting the sky, and he wrote extensively about his techniques.

Early 19th-century artists would often use a fine-tipped brush or a pen with a fine nib to paint fine lines in watercolour paintings. They would typically mix their watercolour paints to a slightly thicker consistency than normally taught today to prevent the paint from spreading too much, and carefully apply it to the paper with a steady hand. Another technique they might use is called dry-brushing, which involves using a relatively dry brush with a small amount of paint to create thin, delicate lines. Some artists might also use a technique called "scratching out," where they would use a pointed tool to scratch away the top layer of paint to create fine lines or highlights.

MIXING PAINTS

Mixing paint to match the colours of a painting you wish to copy or the style you wish to imitate can be a challenging task, but with the right approach and a bit of practice, you can achieve accurate results. Here are some general steps to follow. Start by simply observing the painting. Look closely at the colours in the painting and try to identify the various shades and hues used. Note any dominant colours or colour combinations, as well as any subtle variations.

CHOOSE YOUR COLOURS

You should use the best high-quality artist-grade paints you can afford for better colour accuracy and that are close to the picture you are copying or those used by the artist you are paying homage to. If money is tight, see the method below for mixing and you only need to buy the same five colours to produce a full range of colours.

.

If you are using your own home made paints you will need to have colours close to these five colours. You will need are a warm Yellow, a Red shade like Alizarin Crimson, a strong Blue shade like Ultramarine Blue, an earth colour like Burnt Umber and White. Find a colour chart, identify the colours and mixes mentioned later, and mix up the basic colours you will need. Then let them dry in pots or ice cube trays for later use. Victorian art tutors taught that for landscapes the student should have a basic palette consisting of, a tin sketching box, containing Gamboge, French blue, Raw and Burnt Sienna, Yellow Ochre, Alizarin Crimson, Ultramarine Blue, Venetian Red, Vandyke brown, Prussian Blue, Olive Green, Brown Madder, Crimson Lake, Indian Yellow, Raw and Burnt Umber and a bottle of Chinese White. So, see if you can mix this assortment of colours from your basic five. This will go a long way to teaching you the art of mixing colours and which colours to use.

This is the method of mixing you can use. Start with a small amount of the three base colours by mixing all the primary colours (red, blue, and yellow) to create the base colour using a small palette knife. First, you must concentrate on getting the right tone, not the colour you are copying. Use white and/or yellow to lighten the tone of the mixture and burnt umber and/or blue to darken it. You can put a dab of the mixture on a piece of card and hold it next to the piece you are copying to compare the tone.

Once you have achieved a similar tone or shade, only then do you next concentrate on achieving the right colour or hue, but remember as you adjust the colour, to keep the right tone. Using this method, you cannot make a mistake that cannot be recovered from. Just keep working and mixing the paints till you achieve a match. If you end up with too much colour on your palette, take some aside for later and keep working on what is left. The more you practice, the shorter the time it will take. Adjust the colour as needed. Check your paint mixture against the colours in your references, and adjust the colours as necessary to get a better match. You can add a small amount of paint of a different colour to adjust the hue or shade. Remember, practice makes perfect, so don't be discouraged if it takes some time to get the hang of mixing colours. With patience and persistence, you can achieve great results!

BASIC PAINTING TECHNIQUES

When painting, work in thin layers, building up the colours gradually. This will allow you to achieve greater accuracy and depth of colour. As you paint, periodically compare your work to your references to ensure that you're on the right track. Early 19th-century watercolourists used a variety of techniques, some of which are still used today. Each artist had their unique style and approach, but these techniques form the foundation of the watercolour tradition. Here are some of the most important ones::

Washes: A wash is created by applying a thin, transparent layer of watercolour paint to a large area of the paper, usually using a large brush. Washes can be used to create smooth gradations of colour, to establish the overall tone of a painting, or to create a background.

Wet-on-wet: This technique involves applying wet paint to wet paper, allowing the colours to blend and bleed into each other. Wet-on-wet can be used to create soft, flowing effects, such as clouds or flowing water.

Dry brush: Dry brush involves using a brush with very little water, allowing the paint to be applied in a drier, more textured way. This technique is often used for creating fine details, such as tree branches or fur on animals.

Glazing: Glazing involves building up layers of transparent paint to create a deep, luminous effect. Each layer must dry completely before applying the next. This technique can be used to create rich, intense colours and a sense of depth in a painting.

Lifting: Lifting involves removing or lightening areas of paint with a damp brush or sponge. This technique can be used to create highlights or to correct mistakes.

Dry-on-dry: This technique involves applying dry paint to dry paper, allowing for fine, precise lines and details. Dry-on-dry can be used for creating intricate details, such as blades of grass or feathers on a bird.

TRANSFERING YOUR SKETCHES

Most artists of this period would start their painting by laying a single colour over the whole sheet of paper in flat wash to give it a background tint that would harmonise the other colours that are painted on it. First, the sketch copied from your designs are made in ink or pencil and then shaded in tones of grey before been covered with a tinted wash. This is where the pre-shaded illustrations in this book can be used as a guide but make sure the direction of the light falling on the subjects is from a consistent direction.

In making a sketch for a water-colour landscape, it is best to sketch very lightly at first, so that the marks can readily be removed if required, because hard rubbing the surface of the paper is liable to leave worn patches. Proceed with all the minute details, sparing no pains in the sketching. The time spent now is worth it and the secret of a good painting. The appearance of a good sketch should be lightness in the extreme distance, working a little stronger as the foreground is approached. In the foreground, boldness, observing a fineness of line on the light side, and breadth and depth on the shade side, so that even the pencil sketch may be suggestive of what the final picture will be.

For watercolour painting the paper should be mounted, that is, pasted, or "stretched" on a drawing board or thick mounting board (London or Bristol Board), Failing that a few thinner card boards glued together and weighted till dry will do. Then with the sheet be rather smaller than the board, bend up a margin about half an inch wide all round. Turn the paper face downward, and spread water over the back (now uppermost) with a clean sponge, allowing it to soak in for a minute or two, but keeping the surface equally moist all over.

Next raise the paper by the edges, turn it rapidly over again, so that the wet side may come next to the board, and apply strong flour paste to the turned-up edges. Rub these down, and in doing so draw the paper outward. It is a good plan to burnish the edges well with the back of a spoon, by which means the air is pressed out, and the proper adhesion is ensured. After that, while the paper dries, the board should be positioned horizontally. It should be closely monitored while drying, and if any areas develop "blisters"

that don't appear to go away, a few holes may be poked in them with a needle, by which the air will escape, and the problem remedied. If not, moisten the paper's surface with the sponge, paying specific attention to the edges.

When the paper is dry, you may start to transfer your design to it. Start across the top and work your way down to the bottom. This lessens the chances of you smudging your drawing with the side of your hand as you work. Have a piece of bread handy to lighten or erase any pencil marks with light rubbing. Use a harder pencil for any points of distinctness you wish to create. No amount of shading or colouring, however well done, will improve a bad drawing, whilst a good outline will often clearly represent the object without either shading or colour. The student is advised to thoroughly review and correct the sketch before starting to colour it.

When using inks, dilute the ink into three parts. Use the lightest for every part of the drawing excluding the highlights. When this is properly dry, use the second darker shade ink for the mid-tones and when this is dry, finish with the third and darkest shade. Then leave to dry completely, ready for the next step. When your under-drawing is dry, you can use a fixative like boiled milk or proceed with laying the tint.

Make sure you use two cups of water, one to rinse the dirty brush the other for clean water to mix your colours. When mixing large quantities of colour light tints and washes, it is sometimes handy to contain them in a small saucer. Now apply a light tint of colour to the whole sheet. This is best done with a large brush. Hold the paper and board it is mounted on, at a slight angle, while working horizontally across the paper from top to bottom. In order that the colour may flow easily and cover the flat surface evenly, it should be a thin mix.

If, when dry, it should prove not dark enough, another wash can always be applied, but it is very difficult to lighten a tint which is found to be too dark. Each stroke should overlap the previous one, picking up the excess moisture and gradually moving it to thee bottom of the page. When you get to the bottom, dry the brush on a paper towel or cloth and use it to pick up the extra moisture with one final sweep. Press your blotting paper upon it to absorb the superfluous moisture.

The wash does not have to be of one single colour. Some artists used blue for the top third of the painting, a cool receding colour, going into a warm yellow ochre for the remainder. This can be gently graduated colours or allowed to run into each other. Do not touch your painted surface until it has dried after applying your colour. Whatever fault may appear, your tampering in the wet paint will only make things worse, ruining the paper's grain and rubbing up the surface.

English watercolourists were especially known for there lack of using pure white paints in their pictures. Instead blank pieces of paper were left to contrast the painted areas. This was often refereed to as areas of "Reserved White". This can be achieved great attention to detail or with modern mediums like masking fluid that is applied at the start of the painting. It is then painted over and removed by gently rubbing, when the paint is dry, to reveale the lighter paper underneath. Paint can also be removed while wet by blotting out with a cloth, blotting paper or sponge. The techniques is especially useful for creating clouds in wet sky washes. Sometimes pigment can be removed when dry by gently wetting the area with a brush

in one hand, while blotting out with the other. The technique involves dabbing and not rubbing which will damage the paper surface. Generally it is better, when you have laid on your colour, not to touch it until it is dry ; whatever fault may appear in it will only be made worse by your stirring about in the wet colour, whilst the surface of the paper will be rubbed up and its grain spoiled.

For the sky area a slight hint of indigo was used. Cox instead recommends having the colours Gamboge, Sepia and Prussian Blue handy. If the tint has not spread evenly, when it is dry, a sponge softened in water, and passed two or three times across the drawing, will restore it. The sky can be given depth by greys and hints of red. Another mixture for the sky can be composed of Indigo and weak Cobalt, with a slight touch of Venetian Red. Trees in the foreground, around cottages can be strongly marked with a tint of sepia and indigo. While the distant trees have a tint of gray, their lights heightened with gamboge and ochre, and their shades rendered deeper with indigo. Foliage colours can also be painted with Raw Sienna, Indian Yellow, and Indigo, in varied proportions.

By positioning a piece of paper with a straight edge in the direction of the light and gently wiping the exposed area with the damp sponge, it is possible to successfully create light rays that come from windows, openings in clouds, and other sources. As a general rule, the brush for broad shades should be pretty full of colour but for finishing, all the colours are worked much drier, and the brush worked chiefly on the point.

The distant hills can be carefully painted in with mixed grey, and increased with more colour as you proceed to-ward the middle distance, adding more or less Madder Brown and Yellow Ochre as the subject may require. These hills may be strengthened, if required, with a little French Ultramarine Blue, and perhaps warmed with a little Crimson. The sky and hills should be finished before the trees are commenced.

When painting the trees, use a light touch, leaving little openings now and then for the light to strike through. Begin at the top and working downward, with your brush pretty full charged, varying the greens as you wish them, making them with Gamboge, Raw and Burnt Sienna, and Prussian Blue. Increase the tone of the shadows with another brush, but with the same colour, only adding a trifle more blue, and some Crimson Lake, to make a neutral tint. The greenery that receives sunshine should take on a yellow tint. Vandyke Brown paint is then applied to the stems and trunks. When the colours are dry, apply them again to the foliage in order to achieve the desired form and depth. Paint the network and branches of the trees with a mixture of Cobalt Blue and Vandyke Brown for winter trees.

The tree trunks can first be given a light wash of Yellow Ochre over the whole, followed by a Grey, formed of Indigo and Brown Madder, or the Mixed Grey for the shadowed elements, such as the cast shadows of the branches. When this is dry put in the dark markings with Vandyke Brown and Lake, the warmer parts being heightened with a little Burnt Sienna. Indian Yellow and Indigo make up the Green.

Indigo is used for shading Prussian Blue, and, when mixed with Gamboge or Indian Yellow, makes an excellent Green for trees and foliage in general. Cobalt is a fine clear Blue, used in skies, and water. It makes good Greys for clouds with Lake, Light Red, or Madder Brown. This refers also to French Blue or

Ultramarine. Other Browns besides Sepia are Vandyke Brown and Burnt Umber. Lake can be added to any of these to give them a warmer tone. Madder Brown, or Brown Madder, is a transparent Reddish Brown very useful in warm shadows, and when mixed with Indigo forms excellent Greys.

Burnt Sienna is a bright Red-Brown, and is very transparent. It is exceedingly useful in shading Yellow colours, and as a warm tint over Raw Sienna, Indian Yellow, or Yellow Ochre. To give trees the mellow, golden tint seen in the autumn, then lightly wash over them. For this, Indian Yellow can also be employed. Lake is a beautiful Red colour. The one usually called Lake in old painting manuals is Crimson Lake, The Crimson is Red with a Blue tinge, tending towards Purple, whilst the Scarlet Lake is Red with a Yellow tinge and an Orange undertone; both of these colours are frequently utilised as washes over the paper. When laid on very thinly, they give various shades of Pink.

Light Red, Indian Red, and Venetian Red are colours not so bright as Vermilion, but are extremely useful in Landscape painting. They are used in painting brick buildings, tiles, &c, besides the various hues and washes into which they enter. They may be shaded with Vandyke Brown or Burnt Umber.

Gamboge is a clear bright Yellow, which mixes well with any other colour. It is very transparent, and lies very flat when applied thinly. Its use in mixing with Blue, to form Green. Compared to Gamboge, Yellow Ochre is thicker and neither as bright nor translucent. It is used in stone-work, and in the foreground, and mixed with Cobalt and Light Red for skies, distances, and mountains. It may be shaded with Burnt Sienna, Vandyke Brown, Burnt Umber, or Sepia.

Lamp Black is the Black most generally used in Landscape painting. Mixed with Raw Sienna or Indian Yellow it makes a rich quiet Green, and with Light Red, Venetian, or Indian Red, it forms useful warm Browns for earth, brickwork, etc. Except in works that are all in one colour, it is hardly ever employed alone.

A good neutral mixed grey colour, can be made with Lake, Indigo, and Vandyke Brown, or Sepia. Mix the Lake and Indigo to a Purple tint, and add the Brown gradually till the desired colour is obtained. Before starting the basic colouring in of the picture, this grey, when applied thinly, will be found to be quite helpful in creating the overall effect of light and shade. It offers the shadows depth and harmony, and depending on the situation, it may be either warmer or cooler by adding additional Red or Blue.

Based on a palette of Gamboge, Cobalt Blue and indigo Samuel Prout recommends these mixes should me memorized by his students.

Gamboge	And light Red	Rich Orange
Gamboge	And Burnt Sienna	Rich and deeper
Gamboge	And Burnt Umber	Yellow Brown
Gamboge	And Vandyke Brown	Ditto. Deeper
Gamboge	And Sepia	Warm Green
Gamboge	And Cobalt	Pale Yellow Green
Gamboge	And Indigo	Green
Cobalt	And Light Red	Pure Ariel Grey
Cobalt	And Burnt Sienna	Warn Grey
Cobalt	And Burnt Umber	Colder Grey
Cobalt	And Vandyke Brown	Ditto. Colder
Cobalt	And Sepia Brown	Quite Pure Grey
Cobalt	And Madder Brown	Purple Grey
Cobalt	And Light Red	Green Grey
Indigo	And Burnt Sienna	Rich Warm Green
Indigo	And Burnt Umber	Ditto Colder
Indigo	And Vandyke Brown	Still Colder
Indigo	And Sepia Brown	Quite Cold
Indigo	And Madder Brown	Purple Grey
Indigo		

Early 19th-century artists also experimented with various techniques and additives to create effects in their watercolour paintings. Here are a few examples:

Wax resist: Wax resist involves applying a thin layer of wax over certain areas of the paper before painting. When the paint is applied over the wax, it resists the paint and creates a unique effect when the wax is removed.

Scraping: Scraping involves using a sharp tool to scrape away paint from certain areas of the paper. This technique is often used to create highlights or to add texture to a painting.

Splattering: Splattering involves flicking or dripping paint onto the paper to create a random, textured effect.

Blowing: Blowing involves blowing air onto the paint while it is still wet to create patterns and shapes.

Honey: Used as a humectant, (absorbs and holds water) to prevent the paint from drying out too quickly on the palette.

Gum tragacanth: A natural gum from middle eastern legumes of the genus Astragalus, that was added to watercolour paint to increase viscosity and gloss.

Sugar: Used as a binder to help the paint adhere to the paper.

Soap: Used to create a frothy effect in water or for cleaning brushes.

White vinegar: Used to fix the dye and create a mottled effect in the paper.

Egg white: Used as a binding agent and to create a glossy surface on the paint.

THE MOUNT FOR PAINTINGS

Early 19th-century artists typically mounted their finished watercolour paintings and drawings on a rigid support such as a board or card. This was done to provide stability to the fragile and delicate watercolour paper and to prevent it from buckling or sagging. The mounting process typically involved cutting the watercolour paper to the desired size and shape and wetting the paper to make it more pliable and to prevent it from curling during the mounting process.

The edges of the paper, to around 1/2" inch, were then neatly bent up and then a layer of adhesive was

applied to the underside of the folded edge of the paper. The adhesive used could be either animal glue, such as rabbit skin glue, or a paste made from wheat starch or rice starch. The wet paper was then placed onto the prepared board or card while smoothing out any wrinkles or bubbles. The paper was then allowed to dry completely while still mounted on the board or card.

Once the finished watercolour paper was fully dry and mounted on the board or card, the artist could then apply a protective varnish or fixative to the surface of the painting to further protect it from damage or fading. It is worth noting that the mounting process varied among artists and could differ depending on the type of support used, the size of the painting, and personal preference. Once the painting is complete, the forger will need to add the finishing touches. This may include signing the painting or adding a date.

CRAQUELURE

Mostly found on oil painting but where a watercolour is varnished, craquelure is the cracking that occurs on the surface of a painting over time. Art forgers can create craquelure by using a heat gun or by applying chemicals or commercial crackle medium to the surface of the painting that causes the paint to crack when it dries. Another method forgers use is to create these cracks by scratching or scoring the paint surface. This method can be used to create a more realistic appearance, but it is also more difficult to control.

ACTIVITY

Creating an aged fake decorative crackle on a modern watercolour can be achieved through a process called "crackling." Here's how to do it:

Materials needed:

Watercolour painting, Glue, Paintbrush, Hairdryer, Optional: gold or metallic paint

Steps:

Apply a glaze of Gum Arabic over the top of the watercolour painting using a paintbrush. Be sure to apply it in a thin layer, as thick layers will not crackle properly. Use a hairdryer on a low heat setting to dry the glue. This will cause the glue to shrink and crackle as it dries. Once the glue is completely dry, you can add additional paint to accentuate the crackle effect. It is important to note that the crackle effect may vary depending on the thickness and number of layers of the varnish applied, as well as the specific techniques used to apply and manipulate the varnish. It may be helpful to experiment with different methods and materials to achieve the desired effect.

STAMPS, SEALS, AND MARKS

When the collecting of drawings, etchings and prints was at its height, many great collectors had thousands in their possession and it was their habit to assert their ownership by adding their personal mark to the backs of the pictures. This was either done with a stamp or some other mark, even a wax seal. Sometimes alongside the mark can also be found the collection inventory number. These thousands of different ownership marks have been collected over the years by enthusiasts and researchers listing and collating them.

Once the collector's mark has been identified, they can lead to the actual archives of the collection or even Royal households, where historic papers can reveal information on when the items were bought and from whom and even details of the artist that created them. To most dealers and collectors the mere sight of these marks on the back of the work negates the need for any provenance research, as their presence proves that the picture existed in the past and was a prized piece in some notable collection. They also hold the promise to the buyer or the dealer that future research of the marks might increase the value of their find. So even in the absence of a proper provenance, these marks add value especially if the work could have once graced a royal collection, the household of a leading historic figure or even just a prominent collector

Added to this, many of the marks are often hard to distinguish. The marks are often deliberately small, so as not to impinge or distract from the overall aesthetic of the artwork. Sometimes they are difficult to read because they are rubbed or have become discoloured. Frequently, a stamped seal is a partial imprint because of the angle of application or not enough ink applied to the stamp. Wax seals dry out, fracture and often have missing parts. With modern technology and even with smartphones it is easy to magnify or take close-up pictures. There is now plenty of imaging software available that can be used to study and alter the variables like brightness and contrast. Then it is just a matter of locating the mark online or in reference books to find to which collection it belonged.

Although it is not always possible to identify the artist or the collection, it still adds value and credibility to the work. This is why art forgers have perfected many ways of recreating collector's marks. These vary from having a selection of stamps professionally made to adapting old children's printing sets. The forger Eric Hebborn perfected the skill of copying collector's marks free-hand, sometimes dipping his pen in the grounds of the coffee cup he had just finished drinking. Forgers take advantage of the many verified incomplete collectors marks by leaving them half-finished to add veracity, or distressing the finished mark lightly with sandpaper. Similarly, wax seals are baked in the oven, while attached to brown paper or grease-proof baking paper to simulate the cracks of age and then transferred to the artwork.

VARNISHING

There were no water-based varnishes available for artists in the early 19th century, as synthetic resins and polymers that are used in modern water-based varnishes were not developed yet. Early 19th-century artists typically used natural varnishes such as damar, mastic, and copal, which were dissolved in solvents like turpentine or oil of spike lavender. These varnishes were not water-soluble and could not be thinned or cleaned up with water.

ACTIVITY

Spiked lavender is a type of lavender essential oil that has been infused with spikes of lavender flowers. Here is a simple method for making spiked lavender at home:

Materials:

Lavender essential oil, Dried lavender flowers, Glass jar with lid.

Instructions:

Fill a glass jar with dried lavender flowers. Pour lavender essential oil over the flowers, making sure they are completely covered. Seal the jar tightly and let it sit for at least two weeks in a cool, dark place. After two weeks, strain the mixture through a cheesecloth or coffee filter to remove the flowers. Pour the spiked lavender into a clean, airtight bottle or jar and store it in a cool, dark place. Note: The ratio of essential oil to dried flowers will depend on personal preference, but a good starting point is 10-20 drops of essential oil per 1/4 cup of dried flowers. Oil of spiked lavender is commonly used as a solvent for natural resins, including Damar resin. It can dissolve Damar resin when heated together and mixed well. This mixture can then be used as a varnish or medium for oil painting

In the early 19th century, it was common for watercolour paintings to be finished with a varnish to protect the surface and enhance the colours. As mentioned the varnish was typically a natural resin dissolved in a solvent, such as Damar or Mastic dissolved in turpentine. Some artists may have also applied wax to their finished watercolours, either alone or on top of the varnish, to create a smooth, polished surface. Wax could be applied by rubbing it onto the painting with a soft cloth or by using a heated tool to melt and spread it evenly. However, the use of wax was not as common as varnish.

ACTIVITY

Preparing Damar varnish at home requires a few ingredients and some basic equipment. Here is a simple recipe for making Damar varnish:

Ingredients:

Damar resin crystals, Pure gum turpentine

Equipment:

Glass jar with a tight-fitting lid, Double boiler or a heatproof bowl and saucepan, Stirring spoon, Cheesecloth, Glass bottle with a lid for storing the varnish.

Instructions:

Crush the Damar resin crystals into small pieces and place them in a glass jar.

Add enough pure gum turpentine to the jar to cover the damar resin.

Put the lid on the jar and shake it well to mix the ingredients.

Empty the jar into a double boiler or a heatproof bowl set over a saucepan of simmering water.

Gentle heat the mixture, stirring occasionally.

Remove the from the heat and let it cool, leaving it till the Damar resin has completely dissolved.

Strain the varnish through a cheesecloth to remove any impurities or undissolved resin.

Pour the varnish into a glass bottle and seal it tightly.

Note: Damar varnish can be flammable and should be used in a well-ventilated area. Avoid heating the mixture over an open flame.

While damar varnish is not typically considered toxic, it can be flammable and should be used in a well-ventilated area. Gum turpentine is also flammable and can cause skin irritation if it comes into contact with the skin, so it is important to take proper precautions when handling it. When working with damar varnish, it is recommended to wear gloves and protective eyewear, as well as to work in a well-ventilated area. If you experience skin irritation or other adverse reactions while working with these materials,

discontinue use and seek medical attention if necessary. Overall, while the ingredients used to make damar varnish are generally safe when used properly, it is important to take proper safety precautions to minimize any potential risks.

Here are several types of natural varnishes available, with each one having its own unique properties and uses. Some of the most common natural varnishes include:

Shellac: This varnish is made from the secretions of the lac bug and is known for its high gloss finish, durability, and water resistance.

Damar: This varnish is made from the sap of the Damar tree and is commonly used in art and woodworking for its quick drying time and ability to enhance the natural color of wood.

Tung oil: This varnish is made from the seeds of the tung tree and is known for its ability to penetrate deep into wood, providing a protective layer that is resistant to water and scratches.

Linseed oil: This varnish is made from the seeds of the flax plant and is known for its ability to enhance the natural color and grain of wood, while also providing a durable and water-resistant finish.

Beeswax: This varnish is made from the wax produced by bees and is commonly used as a sealant for wood and other natural materials, providing a protective layer that is resistant to water and wear.

There are other natural varnishes available as well, made from ingredients such as resin, turpentine, and other natural oils. The choice of varnish will depend on the intended use, the desired finish, and the properties required for the specific project.

PROVENANCE AND SIGNING

Finally, art forgers can also add fake provenance to their forgeries. Provenance is a record of the ownership of a work of art. By adding fake provenance to a forgery, an art forger can make it seem more legitimate. This practice is totally illegal and can have no excuse whereas signing a work with another artists name is not, unless it used for gaining an advantage through deception. TIP : Most art forgers write the signature by copying it while upside down which makes it much easier.

THE EXAMPLES

There now follows a collection of contemporary illustrations for your inspiration. You can copy and use them FREE under creative commons for personal or commercial use. You do not have to provide credit but any mention of this book would be appreciated. So, feel free to scan, trace or photocopy. Use them to make a jigsaw of your composition or tint and frame them. The only restriction is that you are not allowed to resell these as a similar collection. You can of course use this as a colouring book as is with pencils but if you intend to wet the pictures, it might be a good idea to insert some stiff card of thick sheet under the page to stop the water bleeding through to the page underneath.

<center>SO FORGE AHEAD!</center>

Pl. 21

Plate 11.

Plate 12.

Cow-yard

No. VIII

Garret Windows

Well

Water-Mill

Sheds

Pl. 24

No. XI

Plate 8.

Plate 26.

Pl. 23

Plate 10.

Plate 14.

FAKE ART AS A CLASS WEAPON?

As a struggling artist who has witnessed the inequalities of the social system and corruption in the art market, I strongly disagree with the notion that art fakes are entirely negative. Although I do not endorse or encourage anyone to engage in any illegal activity, especially those cases of Art forgery where the underlying motive is greed and profit. I do believe that faking art could be used as a tool to effect change in an unfair society.

Firstly, the high prices commanded by established artists and their works are often inaccessible to the majority of people, this is perpetuating an unjust system where only the wealthy can enjoy art. By creating fake art pieces that are accessible to a wider audience at a lower cost, art fakers are democratizing art and making it available to those who would not otherwise be able to afford it. This, in turn, can lead to a greater appreciation of art and an increased demand for it, benefiting both artists and society as a whole.

Secondly, art fakes can also be used as a form of protest against the established art market, which can be exclusive, nepotistic and inaccessible to emerging artists. By creating fake works of established artists, fakers are drawing attention to the flaws in the system and highlighting the need for change. This has the potential to spark a conversation about the value of art and who gets to decide what is considered valuable.

Lastly, art fakers can also use their skills to create original works that challenge the status quo and reflect the realities of the world we live in. This can include political and social commentary or works that push boundaries and challenge societal norms. By using their talents in this way, art fakers can effect change in society by bringing attention to important issues and sparking conversations that can lead to change.

So, while I acknowledge that art forgery can have negative consequences, such as defrauding buyers and damaging the reputations of established artists, I believe that the potential for art fakery to effect positive change in an unjust society should not be dismissed. I believe it is time to rethink our attitudes towards art fakery and start seeing it as a tool for change rather than a possible criminal act.

Overall, the wealthy use art as a way of maintaining and reinforcing their power and influence in a variety of ways, from signaling their status and wealth to shaping cultural narratives and controlling access to culture. By exposing the hypocrisy of the art world and other industries that prioritize profit over authenticity and integrity, art fakers could argue that by creating fake works of art or other artefacts, they are revealing the ways in which these industries are complicit in perpetuating inequality and injustice. It is worth noting that the creation of art by working-class individuals and groups has often been a way to challenge dominant power structures and assert their own identities and perspectives. For example, the Russian avant-garde movement of the early 20th century was heavily influenced by the ideas of Marxism and sought to create art that was accessible to the masses and reflected the values of the working class.

While art forgery may not be a common tactic used by working-class individuals, there are certainly other ways that they have used art to challenge power structures and promote their own agendas.

During the French Revolution in the late 18th century, many aristocrats and members of the wealthy elite were executed or fled the country, leaving their art collections behind. Some members of the revolutionary government saw an opportunity to redistribute this wealth and began commissioning copies of famous paintings to replace the missing originals in public collections.

During the Cold War, the Soviet Union and other communist governments were known to create propaganda posters and other art forgeries in order to discredit their enemies and spread their ideology. These examples demonstrate how art forgery can be used as a tool for political and ideological purposes. Artists could create forgeries of famous works of art and sell them to wealthy collectors or institutions, using the proceeds to fund political activities that challenge the existing power structures. For example, they could use the money to support grassroots organizations working for social and economic justice.

The current system is also vulnerable to artists creating fake documents or artefacts that challenge the dominant narrative of history, exposing the ways in which the stories we tell about the past are often constructed to serve the interests of the powerful. Many of those secrets, long believed buried and hidden by the rich elite, like the enslavement of the rural classes to work in the factories and mines of the industrial revolution could be exposed or at least brought back into public conversation. For example, they could create a fake diary or letter from a historical figure that reveals a previously unknown aspect of their life or perspective.

Could artists use art forgery to expose corruption or wrongdoing in the art world or other industries? For example, they could create a fake work of art that mimics the style of a famous artist but includes subtle elements that reveal the exploitative or unethical practices of the industry. The artists could surely justify their use of art forgery as a political tactic by framing it as a form of resistance against the dominant power structures that have historically excluded and marginalized working-class people and their perspectives. They could argue that art and culture have been used as tools of oppression by the wealthy and powerful and that by creating forgeries or fake artefacts, they are disrupting these systems of control and reclaiming cultural power for the people.

There is an argument to be made that art forgery is a way of challenging the commodification of art, which has made it inaccessible to many working-class people. They could argue that the high prices of original works of art are artificially inflated by the interests of the wealthy elite, and that by creating forgeries, they are democratizing access to art and culture. Additionally, artists could argue that art forgery is a way of exposing the hypocrisy of the art world and other industries that prioritize profit over authenticity and integrity. They could argue that by creating fake works of art or other artefacts, they are revealing the ways in which these industries are complicit in perpetuating inequality and injustice.

Overall, artists could frame their use of art forgery as a political tactic in terms of reclaiming power, challenging oppression, and exposing the hypocrisy of dominant power structures. This narrative could potentially gain the sympathy of working-class socialists and people on the left of the political spectrum who are critical of the ways in which culture and art are often used to maintain the status quo.

The wealthy have historically used art to maintain their power and influence in a number of ways. Art has long been associated with wealth and status, and owning expensive works of art can be a way for the

wealthy to signal their social status and cultural sophistication. This can help them maintain their social position and gain access to exclusive networks and opportunities. Traditionally, the wealthy have often seen Art a valuable investment, with prices for certain works of art increasing rapidly over time. The financial elite buy and sell works of art as a way of increasing their wealth and diversifying their portfolio.

The wealthy also use art to shape public opinion and influence cultural narratives. They only commission works of art that reflect their own world-view or values, or use their influence in the art world to promote certain artists or styles that align with their interests. They tend to use their control over art institutions, such as museums or galleries, to shape access to culture and promote certain cultural narratives. This can help them maintain their power and influence by controlling the stories that are told about the world.

So on the one hand, using counterfeits to challenge the power structures of the wealthy can be seen as a morally justifiable form of political resistance. If the wealthy have used their power and influence to control access to culture and maintain their dominance, then using counterfeits can be seen as a way of challenging that power and opening up access to culture for a wider range of people. However, there are also potential moral concerns with using counterfeits. For example, if the counterfeits are being used to deceive people or to profit financially, then this could be seen as morally problematic. Counterfeits that are sold as genuine works of art can harm the people who purchase them and can undermine the integrity of the art market. Additionally, using counterfeits as a political tactic can also have legal consequences, which may be seen as morally problematic by some. Depending on the specific laws in a given jurisdiction, using counterfeits could be considered a form of theft or fraud, which may be seen as morally wrong.

Overall, the morality of using counterfeits in political struggle is a complex issue that depends on a number of factors. While using counterfeits to challenge the power structures of the wealthy can be seen as a morally justifiable form of resistance, there are also potential moral concerns with using counterfeits, including the potential for deception, profit-seeking, and legal consequences.

It's important to note that forgery is also often seen as a criminal act, and it can have negative consequences for the artists and collectors whose works are being forged. Additionally, the use of forgery as a political tool can be controversial, and it may not be a universally accepted or effective form of resistance. While art forgery can be seen as a tool for liberation and resistance in some contexts, it's important to consider the ethical implications and potential consequences of using forgery as a political tactic.

Finally lets remember the words of the founding member of the Surly Order of St. Tom, guardian angel of artists that struggle, both living and dead. Tom Keating spoke of his simple desire to paint in the spirit of the masters, under their guidance and his struggle on their behalf against the corrupt art market. Painting as the master might have done, not merely imitating a picture, but inventing a new composition. He pleaded for artists to pick up a brush and explore, not to accept Lord Clark's word, let alone The Burlington Magazine's authority, but to make contact with the masters and to become a part of the fraternity. While discussing the famous artists in his book, The Fake's Progress, Keating stated that: "I found it disgraceful to see how many die in poverty".